CREATIVE
PHOTOGRAPHY

Russ Malkin

BCA
LONDON · NEW YORK · SYDNEY · TORONTO

For Mum, Dad and Chris

This edition published 1991 by BCA
by arrangement with

Kingfisher Books, Grisewood and Dempsey Ltd,

First published in 1990 by Kingfisher Books

CN 4048

Edited by Annabel Warburg and Nicola Barber
Designed by Robert Wheeler
Photographs by Russ Malkin
Illustrations by Kuo Kang Chen
Cover design by David West
Cover illustration by Aziz Khan
Phototypeset by Wyvern Typesetting, Bristol, England
Printed in Spain

CONTENTS

PANORAMA

Have you ever wanted to capture on film a beautiful landscape or a long beach or a view over a city, only to find that you cannot squeeze it all into one picture? By taking a series of photographs one next to another you can build up a panoramic photograph of the whole scene. Panoramas are easy to do; the results are guaranteed to impress.

HOW TO TAKE YOUR PANORAMA

1. Find a spot where you can see the whole view that you want to photograph. It is important when taking the series of photographs that you do not move from this spot.

2. Start from the farthest point on the left and take the first photograph.

3. Try and keep the camera level and the horizon at the same height in the viewfinder as you move the camera to the right.

Top Tip
Try holding the camera vertically . . . the results can be even more impressive!

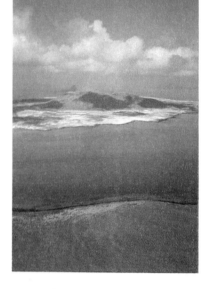

The single photograph above cannot capture the whole scene, but the panorama below does.

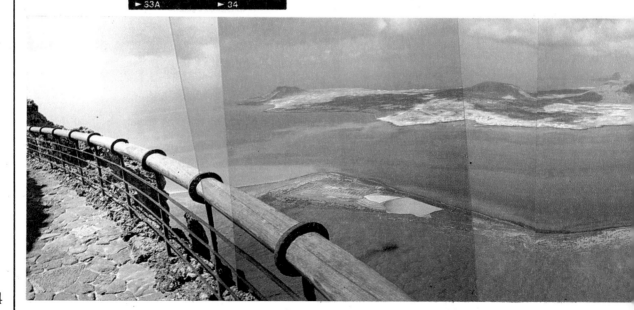

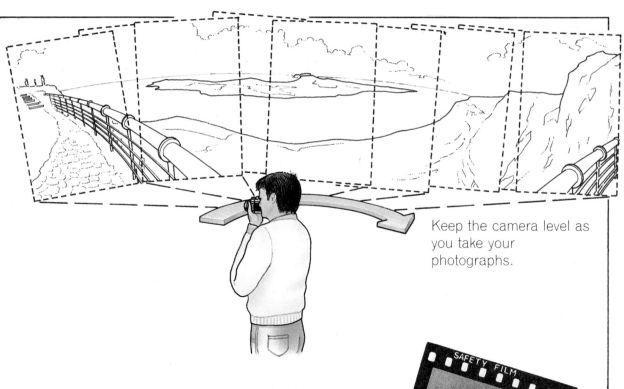

Keep the camera level as you take your photographs.

4. Make sure that you have about a third of your first picture in the viewfinder before you take the second photograph. This overlap ensures that you do not miss any of the view and helps you to join the photographs together later.

SAFETY FILM

Top Tip
Avoid having objects in the foreground.

33A
34

5. Keep taking photographs, each one overlapping the previous one, until the whole scene has been covered.

Note the overlap of the photographs.

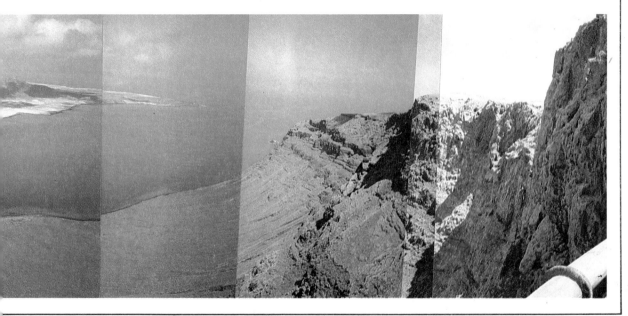

HOW TO MAKE YOUR PANORAMA

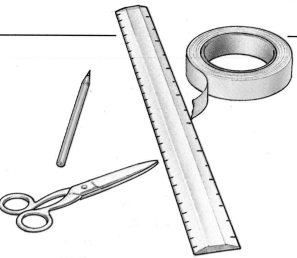

You will need:
scissors
a ruler
sticky tape – preferably masking tape or any tape that can be peeled off the photograph without spoiling it
a sharp pencil

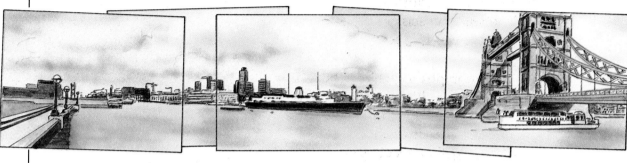

1. Lay all your photographs on the floor to get an impression of how your panorama will look. You may notice that you cannot match up each photograph exactly to its neighbour and that there is a slight curve to the panorama. Do not worry about this.

2. Pick a line that runs across the panorama: it could be the horizon, the sea's edge on the beach, a fence or a row of houses. When joining the photographs together this line must match up from one photograph to the next. We shall call this the **'eye line'**.

The eye line in this photograph is the edge of the water.

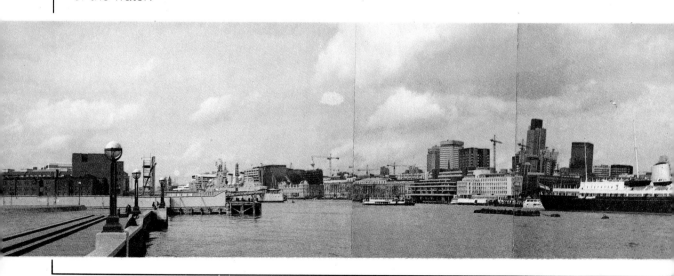

3. Start on the left and lay the first photograph down. Lay the next one down so that they overlap, and match up the *eye line*. Keep both photographs parallel and then carefully stick them together at top and bottom with tape that can be pulled off easily.

4. Pick a point half way along the overlap of the two photographs and, using the ruler and pencil, draw a vertical line down the top photograph. Cut along this line with the scissors and remove the tape.

5. Join the two photographs together again, making sure the *eye line* matches. Using a small piece of tape, stick the two photographs together. Turn them both over and stick them together securely. Remove the tape on the front.

Make sure the sticky tape peels off easily.

6. Repeat this process for all the photographs and gradually build up your panorama.

Top Tip
Stick your panorama on some card and hang it on the wall.

7. The top of the photographs may not all line up but when the panorama is finished, cut along the top and bottom so that they are level.

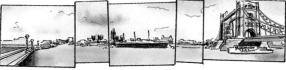

Trim the panorama along top and bottom.

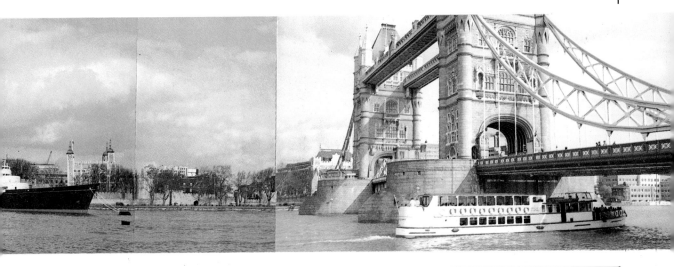

MONTAGE

This is a similar idea to the panorama, but rather than recording a scene as one strip of photographs, a montage is like a jigsaw of pictures. A montage is a fun and effective way of photographing large scenes and interiors.

HOW TO TAKE YOUR MONTAGE

As in the panorama, you take a series of photographs, each of which overlaps its neighbour. It is important to take the photographs in a systematic order to avoid missing any of the scene.

1. Stand near the edge of the scene or in the corner of the room you want to photograph and stay in the same spot while taking the photographs.

2. Starting at the top left, take your first photograph and work across the scene to the right, making sure each photograph overlaps its neighbour. Work across a second row, making sure that there is some overlap at the top with the photographs of the first row. Repeat the process until you have covered the whole scene.

3. If you are not sure whether you have covered the scene, take a few more photographs, otherwise there may be a large gap in the final montage.

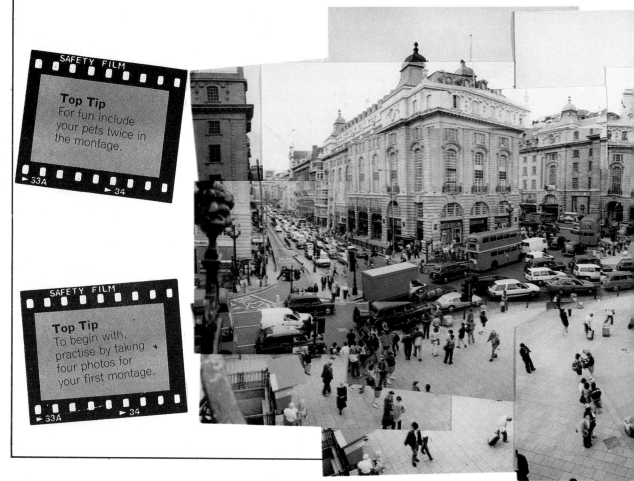

Top Tip
For fun include your pets twice in the montage.

SAFETY FILM
►33A ► 34

Top Tip
To begin with, practise by taking four photos for your first montage.

SAFETY FILM
►33A ► 34

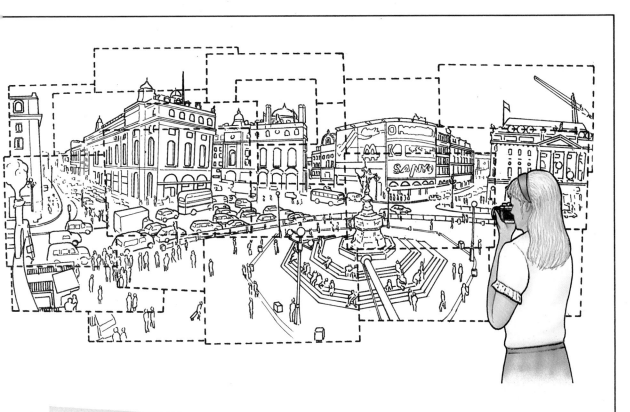

Piccadilly Circus, London

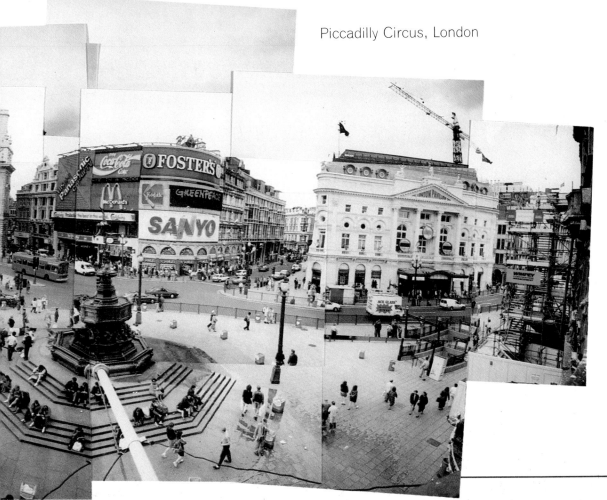

HOW TO MAKE YOUR MONTAGE

You will need:
sticky tape (preferably masking tape—make sure the tape can be peeled off the photos easily)
scissors (be very careful when cutting the photographs)
a ruler

1. Lay all the photographs on the floor to get an idea of how your montage will look.

> You won't be able to match everything up perfectly and you may notice that the montage tends to curve round.

2. Experiment to find which is the best way to overlap the photographs. Pick the most *effective* arrangement. Starting at the top left, pick out the first two photographs without disturbing the rest of the arrangement.

3. Overlap the two photographs and line them up as best you can. Tape them together. Mark a line half way along the overlap and cut along this line through both photographs. Remove the tape.

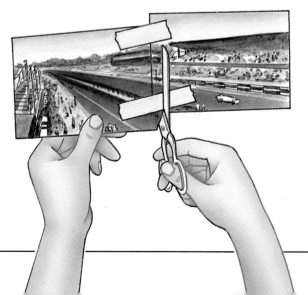

4. Join the two photographs together again with a small piece of tape on the front. Turn the photographs over and stick them securely together down the back.

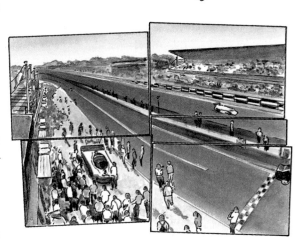

5. Repeat this for all the photographs. Sometimes you may have to cut out extra corners for the best effect, but take your time and ask for advice from a friend or an adult if you need it.

6. Be sure that all the photographs are stuck together on the back before removing the tape from the front. Leave the edges of the final montage uneven – it looks more effective.

You can now stick your montage onto a sheet of card and hang it on the wall for everyone to admire.

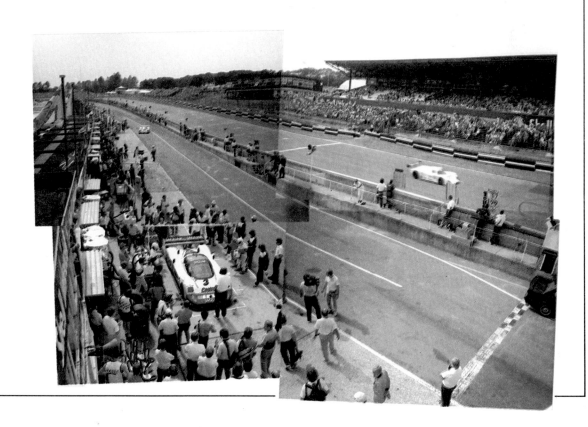

PICTURE PUZZLES

Have fun photographing everyday objects at close range and from unusual angles. See if your friends can recognize what the object is before you show them the picture revealing the secret!

If you want to photograph an object at close range, be sure you can keep it in focus. As a rule do not get any closer than one metre. Pick objects that are quite large and remember to photograph them from an unusual angle.

POP GROUP QUIZ

Think of some pop groups whose names can be suggested by photographs:
For example, the groups suggested by these photographs are 'Queen', and 'The Four Tops'.

Top Tip
Avoid small detail in the picture that will give it away.

SAFETY FILM

►33A ►34

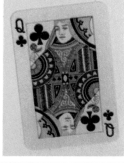

Top Tip
Display the photos upside down to make identification even more difficult!

SAFETY FILM
▶33A ▶34

Display your puzzles by sticking them in a book with the close-up photographs at the front and the answers at the back.

CRAZY CAPTIONS

Take an amusing photograph and write a funny caption underneath.
Hang the photograph on the wall and ask others to think of an amusing caption as well.

I'm working on a lead and I think you might be able to help.

What's up, Doc?

Top Tip
Try and have someone's mouth open so that it looks as though they are speaking.

SAFETY FILM
▶33A ▶34

13

MAKE YOUR OWN CARDS

These are cheaper than buying cards from a shop and they are fun to make and to receive.
The card can be for any special occasion –
Christmas, a birthday, a congratulations card, or a get well soon card. The photograph can be of anything you choose.

1. You will need a large sheet of card. You can buy thick, coloured card from an art shop, or stationer's. It needs to be thick enough to stand up when folded in half. Card that is white on one side will make your message easier to read.

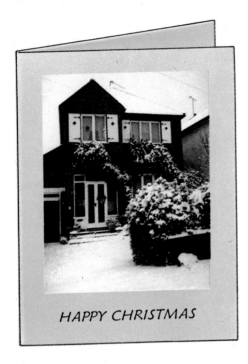

HAPPY CHRISTMAS

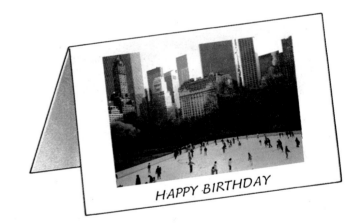

HAPPY BIRTHDAY

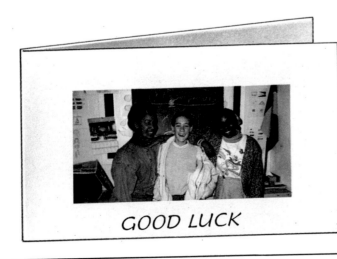

GOOD LUCK

SAFETY FILM

Top Tip
If you are sending a large number of cards, then take several photos of the same scene.

14

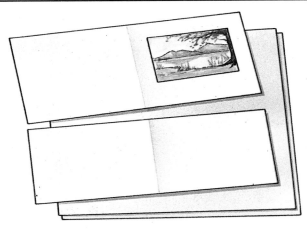

3. Mark out with a ruler the size of card you need. Remember that it has to fold in two.

4. Cut the card out and fold it in two. Place your photograph on the front.

SAFETY FILM

Top Tip
Write inside the card where and when the photo was taken.

2. Choose the photograph that you are going to send and lay it on your card. Leave at least a two-centimetre border around all sides and leave a wider border at the bottom.

5. Glue your photograph down and press, making sure that all the corners are firmly in place. You can decorate the border with felt pen, glue and glitter or coloured stickers. Write your message beneath the picture and inside the card.

PHOTO DIARY

Instead of, or as well as, writing a diary every day or week, start a Photo Diary. It could contain pictures of places you have visited, people you have met, and activities you have taken part in.

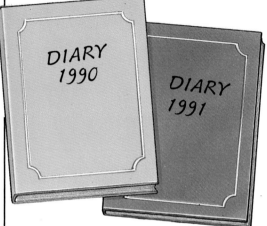

DIARY 1990

DIARY 1991

You don't have to have a photograph for every day. Perhaps once a week take a photograph of somewhere you have been, or friends at school. Find a large book with plain or lined pages and use this as your Photo Diary.

15th July

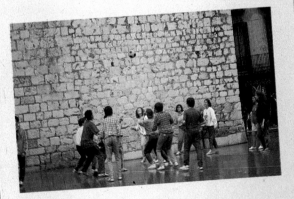

This morning I played football with some friends in the square.

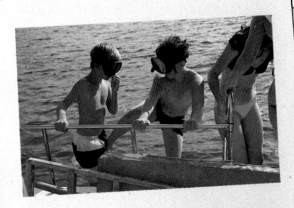

As a special treat, our swimming class went snorkelling at the beach in the afternoon.

Stick each photograph in the book and write underneath all the information about the picture that you can think of.

Remember to date the page.

Top Tip
Photograph your friends. You may see them every day now, but that may not always be so.

SAFETY FILM
33A ▶ 34

Top Tip
Make sure the book you buy has at least 52 pages, for one photograph a week.

SAFETY FILM
33A ▶ 34

26th September

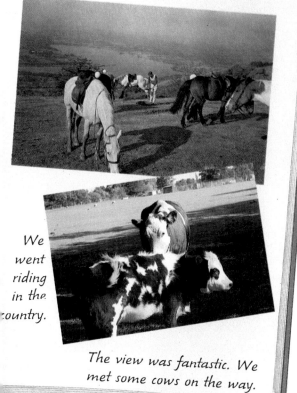

Stick the photographs into the book with glue that doesn't make the writing on the other side of the page run or smudge. Double-sided sticky tape works well. You could also stick things like tickets, labels and postcards in your diary, or add your own drawings.

We went riding in the country.

The view was fantastic. We met some cows on the way.

A DAY IN THE LIFE OF . . .

It could be a day in the life of you, a friend, or your whole family. It could be a day's outing or just a normal day at school . . .

The idea is to have about eight photographs that tell the story of what happened during one day. You then stick the photographs on a large piece of card or in a book and write captions under each photograph explaining what is happening.

Begin with a photograph at the start of the day, waking up, eating breakfast or getting dressed. Make sure that all the following photographs capture the main scenes of the day.

A DAY OUT WITH MY BROTHER

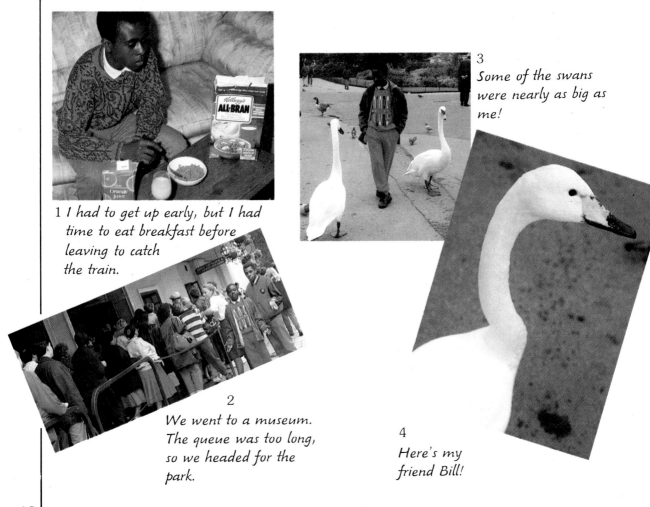

1 *I had to get up early, but I had time to eat breakfast before leaving to catch the train.*

2 *We went to a museum. The queue was too long, so we headed for the park.*

3 *Some of the swans were nearly as big as me!*

4 *Here's my friend Bill!*

HOW TO DISPLAY YOUR PHOTOGRAPHS

1. From all of the photographs that you have taken, select the eight that best represent the whole day from start to finish.

2. Find a piece of thick card that is large enough to take all of the photographs.

3. Lay the photographs onto the card, making sure there is room for all the captions. Then stick the photographs down.

4. Write your captions and put the title in big letters at the top.

Top Tip
Take some funny photographs so that you can write an amusing caption later.

SAFETY FILM

Top Tip
Don't be afraid to set up a shot, or recreate a good picture that you missed.

SAFETY FILM

6

The geese were so tame. I was feeding this one bread straight from my hand.

5 *Andy decided he wanted a hamburger for lunch. I had a hot dog.*

8 *Great! A cup of tea after a busy day.*

7 *This squirrel must have had lunch. He wasn't interested in Andy's peanuts.*

STORY BOARD

A story board is similar to a comic but instead of using cartoon characters, the figures are real people. Get together with some friends and write a story that can be told in 10 or 12 pictures.

1. Decide who is going to take the photographs and who is going to act. Someone can be the Director and it is their job to make sure everyone is in the right place and that the location is suitable.

2. The aim is to make each photograph tell a story. The Director should position the actors correctly and make sure that those people who are supposed to be speaking have their mouths open.

Top Tip
Check the list of Common Mistakes (page 26–29) before you begin.

3. Take the film to the developer's. When all the photographs are developed, choose the ones that you need and stick them on to a large piece of card.

4. Now comes the fun part – using 'speech bubbles'.
On a piece of white paper or card draw speech bubbles of various sizes to fit each photograph. Write in the words that person is supposed to be saying. Cut out the speech bubbles and stick them on to the photographs, matching them up with the right people. You can also add captions under the photographs to explain what is happening.

Top Tip
Take a couple of pictures for each scene, varying the angle slightly.

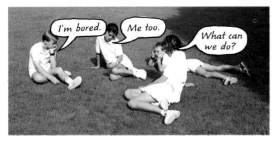

After a game of tennis Steven, Rob, Liz and Sasha have nothing to do.

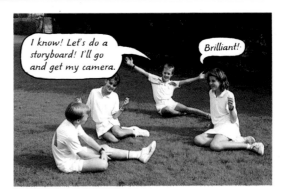

Steven has an idea.

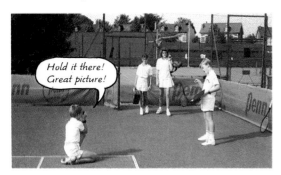

The friends decide who will act and who will organize.

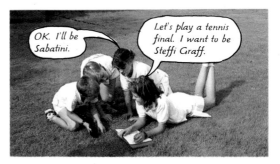

The story has to be written down first. They decide that the story will be about a tennis match.

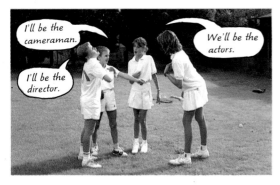

Shooting starts.

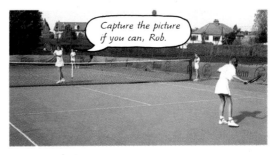

The girls play their game as Steven plans the pictures for the story board and Rob takes the photographs.

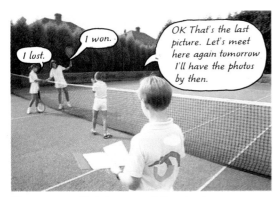

The game finishes and the last photo is taken. The film is taken to be processed.

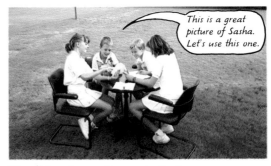

The friends go through their photographs to select the ones to use on the story

TIME LAPSE
A photograph is one of the best ways of recording the passage of time. Here are some ways of using photographs to show how times change.

OLD AND NEW

Go through all your very old photographs or, even better, go to the library to see if you can get some old pictures of your neighbourhood, perhaps as postcards or in old newspapers. Pick the oldest one you can find of a place that you know. Then go there and take a photograph from exactly the same spot as the old photograph.

Try this with a number of different places and put the pictures in a book. It is fascinating to see how places, people and fashions change.

A picture of a High Street in 1901.

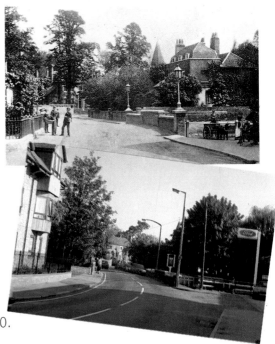

The same view in 1990.

YOU

Collect a picture of yourself every year. Stick them in a book with the date. When you are older, you will be amazed to see how much you have changed.

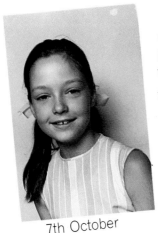

7th October 1977. Aged 8.

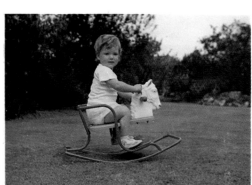

8th June 1970. Aged 18 months.

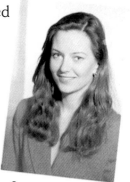

2nd May 1990. Aged 21.

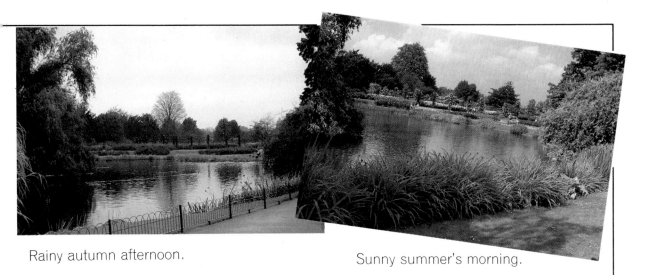

Rainy autumn afternoon.

Sunny summer's morning.

THE SEASONS AND WEATHER

Choose a view that you see regularly and take a photograph of it every time the seasons change and in different weathers. As you collect the photographs, stick them in a book noting when they were taken. When you have a whole year of photographs, you'll be surprised to see how much the same scene can change.

SAFETY FILM

Top Tip
Try to take each photograph from the same position.

33A 34

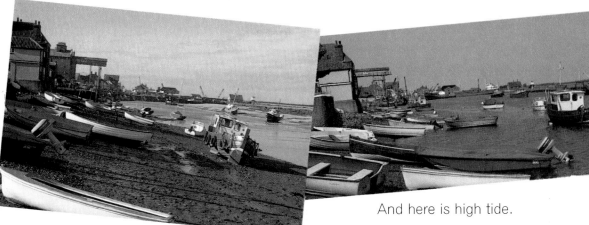

And here is high tide.

If you do not want to wait long for a change in your scene, find something that changes quite quickly. For instance here we have a low tide.

SAFETY FILM

Top Tip
Ask someone to remind you it's easy to forget to take the photographs.

33A 34

FAMILY TREE

It is fun searching through old photographs. By putting them together as a family tree, it provides you and your family with a photographic record of your history.

1. The object is to find a photograph of every member of your family as far back as you can go. Start with your grandparents. You may choose just to explore one side of your family first. Find photographs of your grandparents, your aunts and uncles and their children (your cousins). As you collect the photos, find out when and where each person was born. The more information the better – but remember it all has to fit on to a chart.

1

3

4

7

8

9

10

15

16

1. William Dennett.
2. Molly Dennett. Married 1931.
3. Anthony V. Malkin. Sales Manager.
4. Jill Malkin. Married 1954.
5. Shirley Ann Taylor. Married 1956.
6. Kenneth Taylor. Baker. European Sailing Champion.
7. Lucy Malkin. Married 1978.
8. Gary V. Malkin. Born 1957. Salesman.
9. Steven M. Malkin. Racing Driver.

2. Some of the photographs will be too big to stick on to a chart and some will be too valuable to cut up, so you will have to copy them using your camera.

3. Lay the photograph on a flat surface, making sure it is flat. Stick the corners down with pins or some masking tape (this tape will pull off the photograph without tearing or marking it).

4. Get as close to the photograph as your camera will allow and make sure the picture is in focus. Be sure that you have enough light and that there are no reflections coming off the picture. Try photographing using sunlight.

5. When you have assembled all of your photographs, place them on a large sheet of paper and arrange them in order. Draw lines to show the children of each set of parents. When you are happy that it all makes sense (check with your family) stick the photographs down.

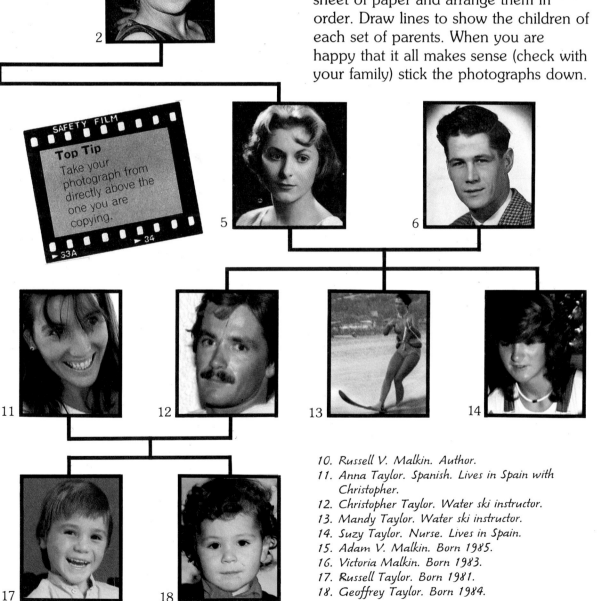

Top Tip
Take your photograph from directly above the one you are copying.

10. Russell V. Malkin. Author.
11. Anna Taylor. Spanish. Lives in Spain with Christopher.
12. Christopher Taylor. Water ski instructor.
13. Mandy Taylor. Water ski instructor.
14. Suzy Taylor. Nurse. Lives in Spain.
15. Adam V. Malkin. Born 1985.
16. Victoria Malkin. Born 1983.
17. Russell Taylor. Born 1981.
18. Geoffrey Taylor. Born 1984.

COMMON MISTAKES

Have you ever taken photographs that are out of focus, blurred, over exposed or badly composed? Here is some advice on how to avoid making common mistakes that spoil photographs.

1. FINGER IN THE SHOT

Make sure your fingers are well away from the camera lens and also from any exposure meters that are on the front of the camera. Remember that on some cameras the lens that you look through is not the same lens that takes the photograph.

2. OUT OF FOCUS

Although there are many cameras, there are only four types of focusing system:
a) It can be pre-set by the manufacturer – so you cannot change the focus. Make sure the subject is at least one metre from you and take the picture in as much light as possible.
b) There may be a choice of symbols that you have to select (*see below*). Try and adjust your composition to match one symbol.
c) You focus the camera yourself by adjusting the lens. If photographing people, always focus on the eyes.
d) Autofocus. Keep the main object you are photographing in the centre of the picture.

Head and shoulders – approximately 1 metre away.

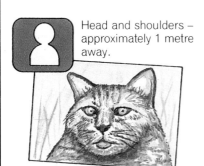

Full body – approximately 2–3 metres away.

Landscape – anything over 3 metres.

3. BLURRED

Sometimes this can be mistaken for a photograph that is out of focus. Blurred photographs are caused by the camera or the subject moving during exposure. To avoid it, try and take your photographs in as much light as possible. If you are photographing a moving subject, move the camera with the action (see Sports Assignment on page 34). Hold the camera still and, if necessary, use a chair or a wall to steady the camera. Make sure that you are standing properly.

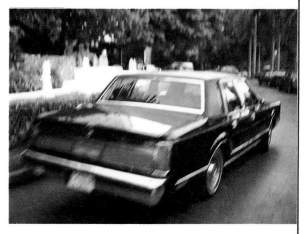

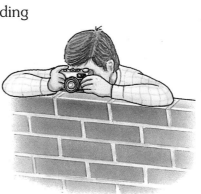

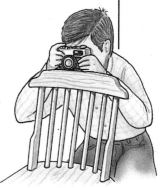

Top Tip
Practise holding your camera in front of a mirror to check where your fingers lie.

Use a wall or a chair to help steady your camera in low light conditions.

Top Tip
If in doubt take two photos with different focus settings.

4. RED EYE

Sometimes a photograph taken with a flash can result in everyone having red eyes. To avoid this, make sure that you have your back to a bright light. This means that whenever your subject looks towards the camera they will see the bright light behind you. The light will make their pupils much smaller and reduce 'red eye'.

5. FLARE

If you take a photograph with the camera pointing towards the sun, the light may reflect off the lens and make strange patterns on your photograph. You may not even see this through the viewfinder. To avoid flare, do not point the camera towards the sun.

▲ Never point your camera into the sun.

SAFETY FILM

Top Tip
The sun should be behind you when taking a photograph.

► 33A ► 34

◄ Colour distortion and dots can occur in your photographs.

6. OVER-/UNDER-EXPOSURE

Sometimes if there is a variation in the amount of light in different parts of your picture, the camera's exposure system can be fooled. This means that your prints can be too light or too dark. Try and take photographs of scenes where the light is evenly distributed. Be careful when taking photographs in the snow as the camera will take a reading off the snow and will not expose your subject properly.

▼ Under-exposed – the photo is too dark.

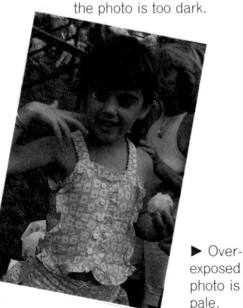

► Over-exposed – the photo is too pale.

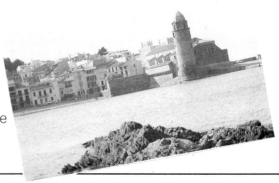

7. POOR COMPOSITION

Remember to check the whole picture before taking a shot, particularly the background. The classic mistake is to have a tree behind the subject. It may make them look like a triffid! (*See Landscape Assignment on page 30*).

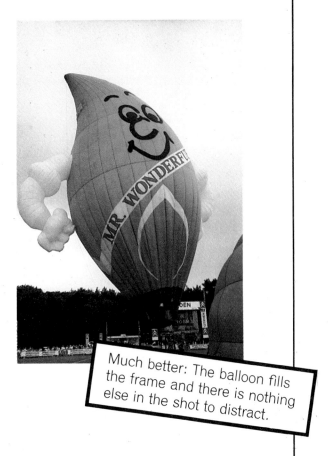

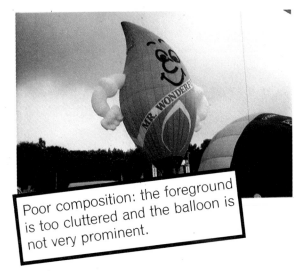

Poor composition: the foreground is too cluttered and the balloon is not very prominent.

Much better: The balloon fills the frame and there is nothing else in the shot to distract.

8. FOGGED OR BLACK PHOTOS

Errors are often made when the film is either loaded into, or taken out of the camera. When you load the film make sure the film is winding on properly and that the camera back is firmly shut. When taking the film out remember to wind the film back into the cassette completely. If your camera has a motor rewind, wait until this has completely stopped before removing the film. Never open the back of a camera when the film is loaded.

Top Tip
Spend a few seconds checking the scene in your viewfinder before you take the shot.

Watch out for trees, or in this case balloons, sticking out of people's heads.

ASSIGNMENT: LANDSCAPES

Landscapes can be photographs of a beach, a country scene or a view over your town or village. They are a general view of a large area, and because of this it is sometimes difficult to make them interesting.

Here are a few tips that can help:

● BREAK THE PHOTOGRAPH DOWN INTO THREE parts. Have something occurring in the foreground, the middle and the background. This gives the photograph depth and helps to lead the eye into the picture.

Top Tip
Make sure the closest object is at least three metres away.

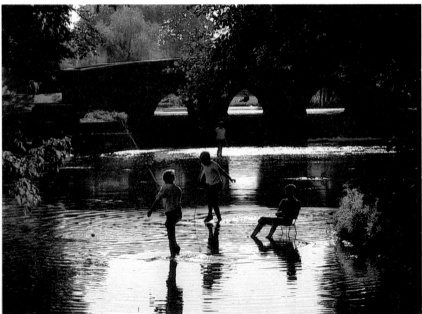

Here the scene is broken down into foreground (the boys), middleground (the bridge), and background (the person through the arch). This will give the photograph depth.

● TRY AND FRAME THE FOREGROUND WITH either a tree or a fence, or building.

● TAKE PLENTY OF TIME LOOKING FOR THE best shot. Get as high as possible and start by looking at the scene with the branches of a tree hanging across one corner of the photograph.

In this case the trees work well as a frame for the scene.

● IMAGINE BREAKING YOUR PHOTOGRAPH INTO three roughly equal vertical sections. Try and make any major feature in the picture occur at these third points. For example a church, or a tree, or a boat. Avoid having the main points of interest right in the middle of the frame. Do the same horizontally as well. Have the horizon one third down from the top.

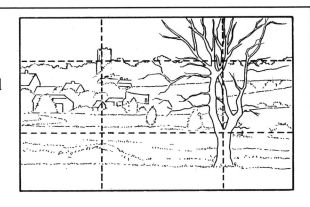

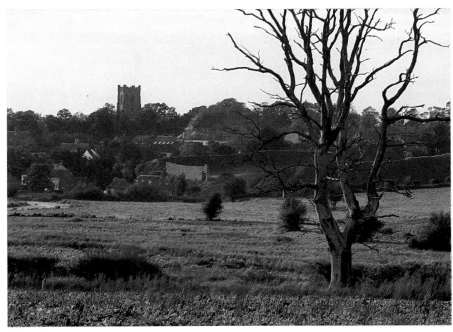

Avoid having any major features right in the middle of the picture. Break the scene down into thirds horizontally and vertically and have features occur at these points. This helps to balance the photograph.

● LOOK FOR WALLS, FENCES, HEDGES or roads that lead your eye into the picture. Don't take the first photograph that presents itself. Look around for a few seconds and try and improve it.

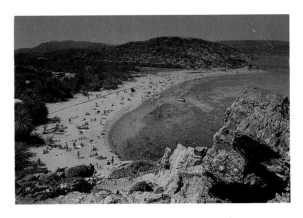

▲ Always look for colour. Bright colours and different shapes make a photograph stand out.

◀ Look for lines that draw the eye into the photograph. It can be a fence, a wall, or in this case, a beach.

31

ASSIGNMENT: PEOPLE AND ANIMALS

The problem with photographing people and animals is that they keep moving! This can be an advantage, as you can direct them into the position that you want.

PEOPLE

● Setting up a photograph need not take long – the quicker you do it the better, as some people may get distracted.

Sometimes people can find it difficult to relax in front of a camera, so try taking pictures without them knowing.

Photograph people in their everyday surroundings.

Top Tip
Do not have too much sky above the head.

Top Tip
Get the people in your photograph to smile.

Hold the camera vertically to fill the frame.

● When taking a photograph of one person or sometimes even two people, try holding the camera vertically. This avoids having empty spaces down the sides of the photo. Also when photographing one person avoid getting the whole body in. Move in a little closer to make the photograph less formal.

● If you do want to set up a group photograph, make sure everyone is relaxed and that the picture is not too formal. They do not all have to be standing shoulder to shoulder. Have some of the group sitting and frame the photograph with the tallest people at the sides.

● Always focus on the eyes. In a group shot, focus on a person who is in the middle, not the person closest to you.

Always carry a camera; you never know who you might meet!

32

ANIMALS

Now for the hard one . . . Try and capture the fun side of your pet or the animal that you are photographing.

● As with people, some of the best pictures are taken when the subjects are unaware that they are being photographed. You will need patience and a quick eye to wait for a good picture to present itself and to capture it on film.

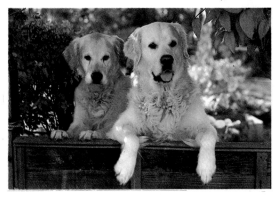

You can always use food to attract the attention of animals. The dogs in this photograph were looking at some biscuits held by someone on my right.

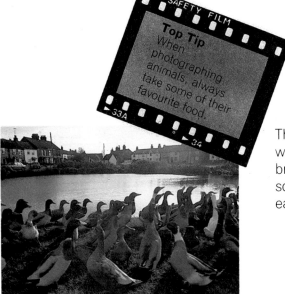

Top Tip
When photographing animals, always take some of their favourite food.

The ducks *(left)* were being fed bread and the squirrel *(right)* was eating a peanut.

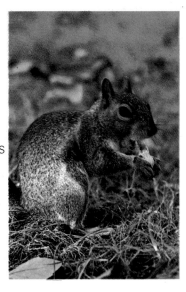

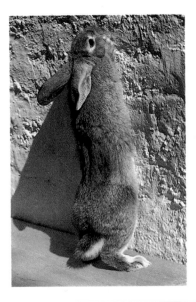

● Get to know the subject that you are photographing. If you can anticipate what the animal is going to do, you stand a better chance of capturing the picture. Your photograph will be much more interesting if the animal is doing something.

● Find the best angle. It may be better to get as low to the ground as possible. Animals photographed from above do not look so good. Also avoid having confusing backgrounds.

33

ASSIGNMENT: SPORTS

The secret here is: be prepared. In most sports you can predict where most of the action is going to take place, for example in the goal mouth at a football match, at home base in softball, at a fence in show jumping. So position yourself as near to one of these points as possible.

● Always follow the action with your camera. Move the camera smoothly and whenever you want to take a picture, press the shutter gently to avoid jogging the camera.

SAFETY FILM

Top Tip
Try and fill the frame. Don't have a little speck in the middle.

►33A ►34

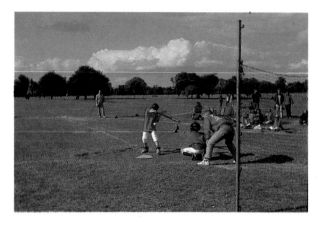

This photograph of the baseball game is not very dramatic. The background is too busy and the main area of action is too small.

● If you have the facility on your camera, set it at a high shutter speed, 125th or higher. If you cannot do this, take your photographs with as much light on the subject as possible, move to a sunnier spot or wait for the clouds to disappear.

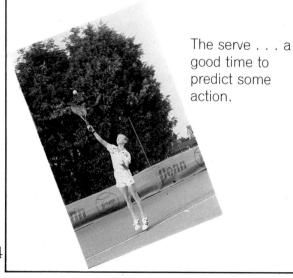

The serve . . . a good time to predict some action.

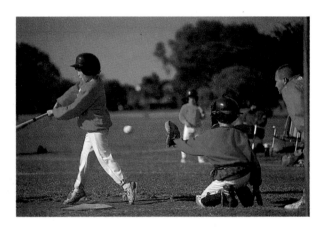

Move in closer and wait for the ball. This photograph is much more dynamic.

● Look for the point of action, for example the serve in tennis as the player is concentrating on the ball.

● Keep the background as clear as possible. This will help the subject stand out.

● Take several photographs, do not just rely on one because many of them may be out of focus.

● If you cannot get close to the action, include the crowd and make it a picture that captures the atmosphere of the event, with people cheering or the colours of the different supporters.

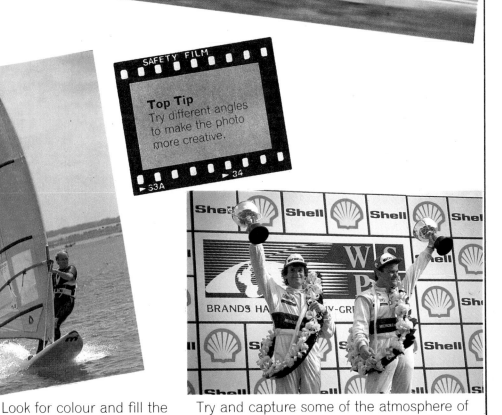

The car is kept sharp by moving the camera with the action. The background is uncluttered and lets the car stand out.

Top Tip
Try different angles to make the photo more creative.

Look for colour and fill the frame, even if it means standing in the water!

Try and capture some of the atmosphere of sporting events. The crowd, pictures of preparation or, in this case, the winners on the rostrum.

CAMERAS

All cameras work on the same principle but they can operate in different ways.
There are four basic types of camera.
NOTE: *All the ideas that are explained in this book can be attempted by any of the cameras mentioned below.*

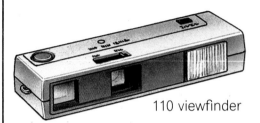

110 viewfinder

35mm compact

autofocus

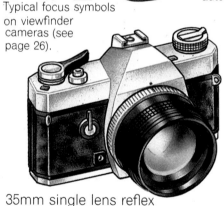

Typical focus symbols on viewfinder cameras (see page 26).

35mm single lens reflex

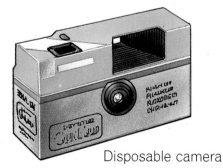

Disposable camera

1. 110, 126, VIEWFINDER CAMERAS

These cameras take good quality photographs and there are three different focus settings. The lens that you look through is not the one that takes the photograph. Also there is no control over which lens, shutter speed or aperture setting to use.

2. 35mm COMPACT AND AUTOFOCUS CAMERAS

The film quality of 35mm is very high. There is some control over the exposure (if required), although most cameras are fully automated. The autofocus cameras will focus for you and many will even wind on and rewind the film for you.

3. 35mm SINGLE LENS REFLEX CAMERAS

The advantage of these cameras is that you look through the lens that takes the photograph and you can change the lens to one that suits the subject. You also have full control over the exposure of the picture. These cameras are expensive.

4. THE DISPOSABLE CAMERA

This is the most recent camera development. You buy a camera that already has the film sealed inside. The camera is cheap and can only be used once. The whole camera is sent off to the processors and the photographs are then returned to you but not the camera. The focus and exposure are pre-set.

36

Fun Disposable Cameras

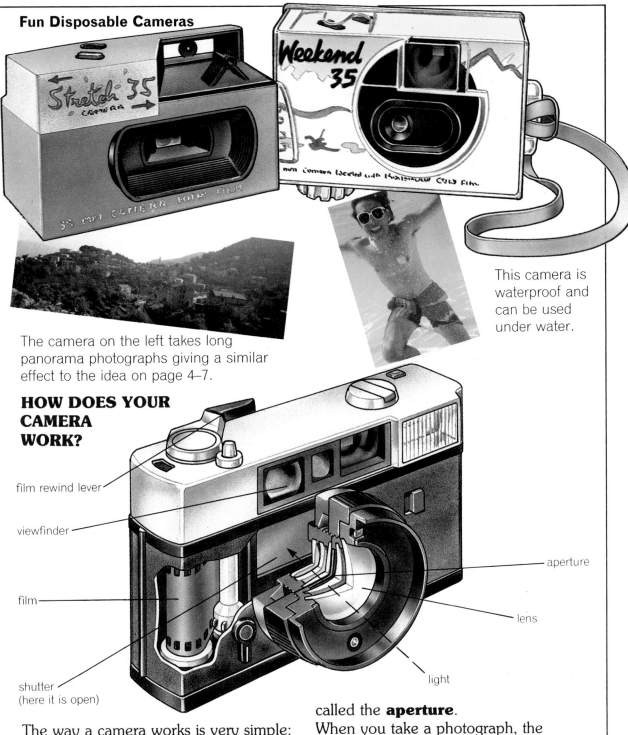

This camera is waterproof and can be used under water.

The camera on the left takes long panorama photographs giving a similar effect to the idea on page 4–7.

HOW DOES YOUR CAMERA WORK?

film rewind lever

viewfinder

film

shutter
(here it is open)

aperture

lens

light

The way a camera works is very simple: The film is at the back of the camera behind a dark screen – the **shutter**. No light can get onto the film until the shutter is open. In front of the shutter is the **lens**. Inside the lens is a hole that can vary in size from the size of a pinhead to the size of a small coin. This is called the **aperture**.

When you take a photograph, the shutter at the back of the camera opens. The light from the subject goes through the lens, the aperture, the open shutter and onto the film where the photographs is recorded. The shutter then closes, you wind the film on and the camera is ready for the next photograph.

37

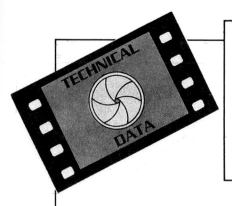

FILM

Although there are many different types of film available, they all fall into two categories — they are either print film or slide film. Unless you intend to use a slide projector to show your photographs, always ask for print film. When buying film you should also specify the type of film, the number of exposures and the film speed.

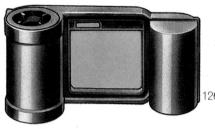

126mm film

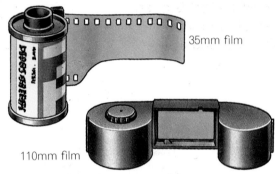

35mm film

110mm film

Always take care when loading your film, and always check that it is winding on between shots.

1. The type of film suitable for your camera. 110, 126 or 35mm (see page 36 to find out the difference).

2. How many exposures you want. This is the number of photographs that can be taken on the film. Normally the choice is 12, 24, or 36 exposures.

3. The speed of the film. Different films react to light in different ways. There are three choices: 100 ASA, 200 ASA or 400 ASA (ASA is simply a term used to specify film speed). 200 ASA is a good general choice. However, if you expect the light conditions to be dull, use 400 ASA. In bright light use 100 ASA as this gives slightly better quality.

FILM TYPES

1. COLOUR PRINT
Used for most general photography. Can be processed easily and cheaply.

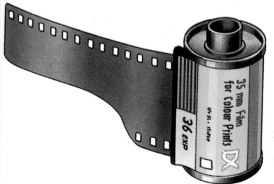

35mm film
100 ASA
36 exposures

2. SLIDE FILM
Generally more expensive to process than print film and can only be viewed with a slide projector or viewer.

3. BLACK AND WHITE
Black and white is fun to use and can produce very creative and artistic photographs. It is expensive to process and to print.

Most films are designed to be used in daylight or with a flash. If you take photographs indoors without a flash you may find the photos have an orange tint. This is because the lights in your house have a warmer glow than sunlight. This effect can spoil the colours in your photographs, so if possible use a flash when photographing indoors.

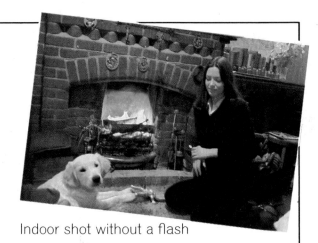
Indoor shot without a flash

QUALITY OF DAYLIGHT

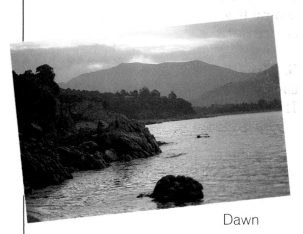
Dawn

DAWN Light is clean and there can be a carpet of mist which looks great. No shadows and a slight blue tint.

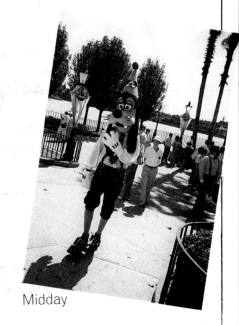
Midday

MIDDAY Not a good time to take pictures. The harsh light can cause hard shadows and it can be very hazy.

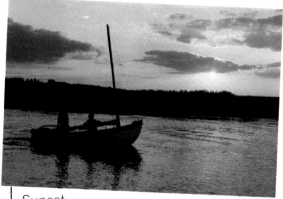
Sunset

SUNSET A good time for a landscape picture. This is the only time when it is advisable to get the sun in your photograph. Watch out for the exposure as the camera can be fooled by areas of dark and light. Take a few photographs varying the amount of sky in each.

INDEX